HENOK MELKAMZER

HENOK MELKAMZER

Telsem Symbols and Imagery

Edited by Elizabeth W. Giorgis

SHARJAH ART FOUNDATION | THE AFRICA INSTITUTE | SKIRA

Cover
Untitled, 2022.
Acrylic on canvas, 180 x 120 cm

Publishing Director
Pietro Della Lucia

Project Manager
Edoardo Ghizzoni

Design
Luigi Fiore

Editorial Coordination
Sataan Al-Hassan
Emma Cavazzini

Copy Editing
Anna Albano

Layout
Sara Marcon

Photo Credits
All exhibition installation
shots were taken by
Shafeek Nalakath Kareem
Getty Images / Santiago Urquijo:
pp. 6–7, 16–17
Getty Images / Eric Lafforgue / Art
in All of Us: pp. 40–41

All works are
Courtesy of the artist
unless otherwise stated

First published in Italy in 2024 by
Skira editore S.p.A.
via Agnello 18
20121 Milano
Italy
skira-arte.com

© 2024 The Africa Institute and
Sharjah Art Foundation
© 2024 Elizabeth W. Giorgis
© 2024 The Authors for their texts
© 2024 The respective rights holders
for the images
© 2024 Skira editore

All rights reserved under international
copyright conventions.
No part of this book may be
reproduced or utilized in any form
or by any means, electronic or
mechanical, including photocopying,
recording, or any information
storage and retrieval system,
without permission in writing from
the publisher.

Printed and bound in Italy.
First edition

ISBN: 978-88-572-5286-5

Distributed in USA, Canada,
Central & South America
by ARTBOOK | D.A.P.
75 Broad Street, Suite 630, New York,
NY 10004, USA.
Distributed elsewhere in the world
by Thames and Hudson Ltd.
181A High Holborn, London WC1V 7QX,
United Kingdom.

Contents

9 Foreword
 Hoor Al Qasimi

13 Introduction
 Julie Mehretu

19 Henok Melkamzer:
 Telsem Symbols and Imagery
 Elizabeth W. Giorgis

43 Henok's World of Telsem
 Semeneh Ayalew Asfaw

51 Works

139 Artist Biography

140 Authors Biographies

142 Exhibition Credits

Foreword

Hoor Al Qasimi

Henok Melkamzer's art is grounded in the ancestral knowledge transmitted to him by his father and grandfather, both of whom are telsem healers. Conceived as a therapeutic practice, interrelated with but also distinct from the history of Orthodox Christianity in Ethiopia, the craft of telsem art has traditionally been passed down from one generation of healers to the next, with only its chosen practitioners able to fully grasp the scope of its mysteries and codes. Melkamzer was initiated into this lineage at the age of seven.

Today, from his studio in the Entoto Mountains, overlooking a eucalyptus forest above Addis Ababa, he makes telsem art that remains rooted in indigenous systems of knowledge production while also extending their expressive power to contemporary social and philosophical issues. In his works, Melkamzer inflects the traditional Ethiopian mode of telsem painting with a contemporary inventiveness and idiom. Beyond their vibrancy and dynamism, as well as the spiritual wisdom they encode, his compositions prompt us to reflect on our human interconnectedness with each other and our surrounding landscapes at a time of increasing division.

Organized by Sharjah Art Foundation, and developed in collaboration with The Africa Institute and the Sharjah Museums Authority, *Henok Melkamzer: Telsem Symbols and Imagery* marks the largest solo exhibition of the artist to date and the first major showcase of telsem art in the region. Curated by Elizabeth W. Giorgis, professor of Art History, Theory and Criticism at the Africa Institute, the exhibition repositions telsem art as an intellectual tradition with a contemporary resonance, not only a "healing art" or a "talisman art," as it has often been narrowly conceived. Comprising over 100 paintings spanning more than a decade of Melkamzer's output, it presents an introduction to his practice and entry point into the intricacies of telsem painting, continuing the Foundation's affinity for spotlighting non-institutional artists and non-Western forms of knowledge production.

In tandem with Giorgis and the exhibition partners, we believe that it is crucial to translate the research and scholarship underlying the exhibition into a published volume. Alongside documentation of Melkamzer's work and a provisional guide to the interpretation of telsem aesthetics, this monograph includes critical reflections from historian, critic and curator Salah M. Hassan, director of the Africa Institute;

Henok Melkamzer in his studio, Entoto, Addis Ababa, Ethiopia, 2023

artist Julie Mehretu; and Semeneh Ayalew Asfaw, a Postdoctoral Fellow at the Africa Institute. These contributions supplement and augment a wide-ranging critical and curatorial essay from Giorgis situating Melkamzer and his practice within both the telsem tradition and the broader contemporary art world.

It is my hope that this publication presents an opportunity for those unfamiliar with telsem art to immerse themselves not only in its critical contributions to fine arts but also its rich and complex history as a site of indigenous knowledge. We believe that Melkamzer and Giorgis's work can provide important resources on contemporary African art practices and understudied indigenous art forms.

Untitled (detail), 2022. Acrylic on canvas, 300 x 130 cm

Untitled (detail), 2018. Acrylic on canvas, 240 x 84 cm. Anonymous Collection

Introduction

Julie Mehretu

On a clear midsummer day in Addis Ababa, my friend Dagmawi Woubshet drove us up to Mount Entoto, the highest peak of the Entoto mountains and the founding site of the city. The entire city of Addis is situated in these verdant Ethiopian highlands sprawling over the hillsides and valleys. They are covered in *eucalyptus* trees, a primary, regenerative fuel source brought to the country initially by emperor Menelik II and planted during the years of Haile Selassie. Considered sacred land, Entoto is also the site of the historic imperial court and numerous monasteries and churches. Every time I have traveled up to Entoto from Addis, it feels as if traveling through the atomization of time, memory, and cosmology. Ascending into the clouds, literally but also viscerally, a source of knowledge and history is provoked on a cellular level, sensually, activated by the trees, earth, air, scents.

Entoto is the home of the painter Henok Melkamzer. He, Elizabeth W. Giorgis, and a few others were outside when we arrived. I vividly remember that entire visit—Henok's contagious smile, deep dark eyes, and his quiet demeanor, not shy, just still like a Bodhisattva. Melkamzer welcomed us with such ease and grace. After greeting everyone, he sat back on his tall stool leaning on the wall of his house. He didn't say much in words, but warmly smiled and nodded his head in a bowing gesture each time I tried to speak to him or look in his direction. You could smell the *eucalyptus* crispness in the air and hear the children playing outside nearby. Melkamzer exuded a kind of fierce confidence and humility simultaneously, not uncommon in Ethiopia.

After some time taking in the sun and catching up, he took us into his studio and slowly began to bring certain paintings outside into the bright light. These were intricate, potent, exuberantly colored, meticulous paintings of eyes, entangled in shapes, geometries, and vines dotted with numbers and symbols. These details are familiar to anyone with a passing knowledge of Ethiopian Coptic illuminated manuscripts or even the kitsch market trinkets that borrow from that language. The history of telsem painting as talismanic healing art and esoteric epistemology, however, predates all of that. I was struck by how different the logic of these paintings felt and the power they held as reverberating objects—resplendent, circuitous, and exacting in their abstracted forms. The elaborate, labyrinthian paintings are first drawn in pencil or in black ink, then some are painted densely with color and others are more sparsely painted with color to accentuate vital nodes. The sheer immensity of the scope of

cosmological sensibility and space in these modestly scaled, shamanistic yet deftly contemporary paintings, is staggering.

Melkamzer told us very little of what he was making or how. Through Elizabeth and Dagmawi, I learned about his father and grandfather as telsem painters and his inheritance of this somewhat secret historical language and philosophy. However, his paintings also felt completely fresh and different from anything I had ever seen before. Melkamzer's work, while pulling from a long history of world-making and knowledge, is also of this moment, time, and place, and some of the strongest new work I had seen on this trip in Ethiopia.

Since I began making art, I have relentlessly studied epistemologies outside Western rational secular, "scientific" modernities: traditional Ethiopian telsem painting, ancient Egyptian stelae and wall reliefs, the fourth and fifth Buddhist caves of Dunhuang in Western China, the history of Yantra painting in India, and the various epistemologies of indigenous Americans from both continents. These multivarious forms of visuality, methods, and philosophies have informed aspects of who I am as an artist and my understanding of contemporary practice, thinking, and painting. I have drawn from all these forms of knowledge as sources in my work and process. As we have witnessed and experienced the failures of utopian modernity, the nation-state, and neoliberalism that is rapidly putting our species and planet at risk, many of us are turning to other forms of knowledge to conceive of and invent new radical liberatory practices to open alternative possibilities and futurities. As Elizabeth will deftly argue, there is no reason to think of telsem painting and Melkamzer's work outside of the history of modernity and contemporaneity.

Art, music, literature, poetry, and dance participate progressively in the construction of every nuanced aspect of our contemporaneity and futurity, fusing parts of our past with new inventions. Melkamzer's paintings are made to actively heal and treat us—as individuals and societies, as species and planet. He pulls from his inherited language and epistemology to do so while also creating a vivid and dazzling new form of telsem painting and aesthetics in contemporary Ethiopia.

Untitled, 2018. Acrylic on canvas, 240 x 84 cm. Anonymous Collection

Henok Melkamzer:
Telsem Symbols and Imagery

Elizabeth W. Giorgis

The exhibition *Henok Melkamzer: Telsem Symbols and Imagery* evolved from an earlier one I held in 2018 at the Modern Art Museum: Gebre Kristos Desta Center in Addis Ababa. The name of the exhibition was *Men Neber*, which means "what was it," a query that aimed to present a honed and nuanced understanding of Ethiopian telsem art that is conventionally coined as "healing art," "magical scroll" or "talisman art" but whose exact meanings and practices are erased from modern education and from contemporary knowledge production, even as the art is still practiced with visual sophistication, astute philosophy, and complex concepts. *Men Neber* also intended to provoke alternative approaches to how non-Western visual studies should be based and reviewed. It urged viewers to critically look into non-Western archival spaces to understand specific cultural histories and powerful artistic accomplishments such as telsem which are still produced in contemporary times but have been abandoned from modern art historical studies and documents.

Certainly, the authority of modernism's official archive and its purported conjecture to singular and credible knowledge packages telsem art in arbitrarily imposed categories, falling short from locating its vigorous imagery within a critical modernist perspective. With ancient inspirations and modern idioms, telsem art contributes to Ethiopian modernism. And I believe it is one of Ethiopia's modernist art practice that challenges the one-dimensional understanding of modernism.

Undoubtedly, exhibiting telsem paintings in the Modern Art Museum has its own complication since the historical and epistemological underpinning of the modern art museum is fraught with the power-laden histories of representation. However, as Okwui Enwezor states: "Exhibitions represent both frames of analysis and topographies of critical practice."[1] For Enwezor, exhibitions of contemporary African art are "places of encounter and sites of production."[2] He says: "[...] the practice, theory, and production of exhibitions is a reminder that every field or discipline requires a frame, or, perhaps, a concatenation of frames within which theoretical reflections and historical analyses can be made."[3] It is within Onwezor's idea of the exhibition space as a site of encounter and critical production that the exhibition *Henok Melkamzer: Telsem Symbols and Imagery* seeks to complicate the conventional narratives behind non-Western art objects such as telsem.

Scholars like Timothy Mitchell argue the history of the West is positioned in such a way that "all other histories must establish their significance and receive their meaning."[4] The anthropologist Talal Asad also thinks, "Many of the things that are thought of as modern belong to traditions which have their roots in Western history."[5] It is this phenomena that we

Untitled (detail), 2022. Acrylic on canvas, 300 x 130 cm

should commit considerable attention to when we anticipate the projects of modernity and modernism, a vexed issue that continues to unsettle contemporary theories of the subject.

Attempting to interpret the space that mitigates the relationship between the "modern" and the "non-modern," and between "tradition" and modernity, the exhibitions call our critical attention to what Mitchell indicates as the hegemonic project of the modern that is staged and performed. Certainly, the teleological understanding of the term "modern," both as a political philosophy and as an economy of culture, has been contested and challenged in multiple ways in scholarly debate. But in Ethiopia as well as in many other parts of Africa, the complexities of the modernist project are informed by the socio-economic phenomena of modernization in contexts of development.

This type of understanding obscures the historical complications that political modernity imposes in Ethiopian spaces of knowledge production, such as in the institutions of modern higher education, that are designed according to Western ideas and ideals from which processes of modernization emanate. The hegemonic values and discourses of modernization and development have subsequently scorned traditional knowledges such as telsem and repudiated such knowledge as "spiritual," "indigenous," and "unscientific." And it is against this background that I argue the art of telsem cannot be excluded from the platforms of modernism. It is our own modernism. The exhibition, therefore, does not aim to contrast and compare telsem art to European modern art but rather to challenge the meaning of the "modern" when the "modern" in telsem is practiced in contemporary times with modernist visual sophistication and complex conceptualization.

Telsem Art in the Western Gaze

Indeed, the formal properties, styles and techniques of telsem fascinates viewers from Ethiopia and abroad. Drawn traditionally on parchment, the sophisticated and intricate lines of telsem consist of symbols that are spectacularly expressive. The *New York Times* art critic Holland Cotter once referred to telsem art as "visual knockouts." But the conventional knowledge base for telsem art in Western art historical provisions had been cabalistic. Modernism, as a field of study, persists in classifying the sophisticated forms, exuberant colors, lines, shapes and conceptually complex arrangement of telsem paintings in categories that are outside of the modernist canon, consequently reducing the ideological and philosophical meaning of the art.

In a review of the 1997 exhibition *Art that Heals. The Image as Medicine in Ethiopia* that was held at the Museum of African Art in New York, Holland Cotter also wrote:

> "[...] the work in *Art that Heals* is, in a sense, only half there. Where, for example, a Western eye sees a scroll as an intriguing form, an Ethiopian sees it primarily as an instrument of use.
>
> And where a Westerner might assume that such scrolls in some sense typify 'Ethiopian culture,' an Ethiopian will know that they represent a tradition now on the wane, confined primarily to parts of the country untouched by modern life.
>
> Modern influences have already begun to change this art. The last room of the show is devoted to contemporary Ethiopian painting that derives its images from scrolls but is produced primarily with a Western audience in mind, one versed in abstract art. In these paintings, the distinction between medicine and estheticism vanishes."[6]

Clearly, Cotter acknowledges the exquisite imagery of telsem art. Yet he places emphasis on the disciplinary divide and difference between the visual languages of European art forms which are modern and historical, and non-Western art forms such as telsem which are perceived as ahistorical objects, and even as they are practiced in contemporary times, they are still approached in anthropological designations. And it is precisely this underlying difference in art historical studies that the exhibition *Henok Melkamzer: Telsem Symbols and Imagery* attempts to extend.

Certainly, the uses of the supernatural in non-Western visual art are grouped together under the rubric of "magical realism" and humanistic scholars have given little significance to the substantial modernist interventions of such works. Clearly these complex works of art cannot be purely described in terms of contrasts such as "reality versus fantasy" or in contexts of a long-gone tradition that has waned. They are still produced in contemporary times, fantastically depicting specific cultural, political, and social experiences of the contemporary moment in both rational and mythical ways.

While telsem art is considerably collected by Western art lovers, it was notably inducted to the Western art platform and market by the French anthropologist Jacques Mercier. His 1997 exhibition *Art that Heals. The Image as Medicine in Ethiopia* particularly stimulated interest in telsem art among Western art critics, curators, and collectors. Mercier worked with telsem artists like Gedewon Mekonnen (1939–1995) whose works are currently in the Jean Pigozzi African Art Collection in Geneva and have been displayed in the museums of the West.

Even though the exhibition tried to loosely offer the principles and concepts behind the artistic practice of telsem, it barely considered Ethiopia's larger political, cultural, and social history that framed and informed the visual form as well as the form's variation and articulation through different moments of history. While the study of the art covered a large ahistorical span of time, it also exclusively referred to Ethiopian telsem art as an ahistorical form of "talismanic" art that is explicitly related to the styles and forms of "talismanic" art in the region and beyond.

The exhibition states the word "talisman" originated from the Franco-Italian religious leader Joseph Justus Scaliger (1540–1609):

> "We owe the word talisman to Joseph Scaliger who coined it as a transliteration of the plural of the Arab word 'tilasm,' then followed its Arab meaning in using it to designate, in both French and Latin, certain objects and stones shaped for astrological purposes."[7]

In some ways then, it is plausible to say the exhibition's analysis of telsem art is informed by Scaliger's postulation which referred to "talisman" art as "objects and stones shaped for astrological purposes." The way many European curators and critics formed and shaped their knowledge of telsem was, therefore, broadly governed by knowledges that were outside of the epistemic locations from where they were produced.

Clearly, categorizing telsem as unassumingly "talisman" is reductive since it omits the specific characteristics of telsem art. The painstakingly detailed and intricate illustrations of Ethiopian telsem paintings cannot be confined to art specifically designed for therapeutic purposes, or simply considered as mere medicinal artifacts, which the predominantly Western field of study continues to brand.

Untitled, 2021. Acrylic on canvas, 60 x 50 cm

It is true telsem paintings are used as therapeutic instruments to cure mental disorders and other illnesses. But it is also true that telsem is primarily an intellectual tradition where critical concepts and ideas are routinely contemplated to unravel complex problems. More than bodily therapeutic concerns, therefore, telsem is also used to solve some of the complex problems of the universe, among them, environmental carnages, war, poverty, and other calamities.

This is not to say that Ethiopian telsem art was not influenced by Byzantium or Islamic "talisman" which Mercier's exhibition brilliantly portrays. But research on telsem art should be studied primarily within its own terms, its own epistemological inquiry, its own epistemic location and history, and within its own meaning and context for a deeper understanding of its relationship to or influence from other knowledge systems.

Here I would like to point one significant query that Mercier brings forth into the exhibition which is the broader relationship of telsem art to other forms of African art. He urges us to search for conceptual frameworks that are beyond the current conventional art historical approaches. He wrote: "[…] characteristics like geometrism, cosmogonic symbolism and up to a certain point, the magnification of the gaze are too broadly distributed to be conclusive; the Christian art of Syria, or of Ireland, is as geometrical as that of Ethiopia and meanwhile certain Ife sculptures, all smooth roundness, make nonsense of the stereotype of African art as geometrical."[8]

I bring Mercier's noteworthy interrogation to reveal the claim and myth of Ethiopian exceptionalism that premises itself on the idea that the art of Christian Ethiopia—that dates back to

Untitled, 2022. Acrylic on canvas, 60 x 50 cm

the introduction of Christianity in the fourth century AD and that consist of illuminated manuscripts, church murals, and wood—is closer to Byzantium than the rest of Africa. But I also bring this query to accentuate the urgency for more interdisciplinary research in African art historical studies that can enrich multiple perspectives. For instance, one of the symbols in telsem art suggests a resemblance to the West African image of an Akan fertility spirit.

Other symbols also evoke relationships to the broader Nile valley civilization. However, whether the art form of telsem is connected to other art forms of the African continent is rarely examined. Research on Ethiopian telsem art is also relatively recent and, in many cases, composed of partnerships with foreign scholars who are exclusively interested in the medicinal aspect of the art, and art institutions who are enamored by the magnificence of the image.

That said, telsem art continues to be exhibited in the galleries and museums of the West in often-reductive interpretive narratives that disregard the complexities as well as the value and dignity of the art. Telsem artists are also described through an ethnographic lens; as distant others who are "healers" or "doctors" living outside their embodied local and global histories.

For instance, in the 2002 exhibition *Art that Heals* which featured telsem artists Gera and Gedewon, the curator Jean-Hubert Martin wrote: "Gera (1941–2000) and Gedewon (born 1939), two traditional Ethiopian doctors, make drawings of figures in their own personal style to treat the specific sickness. At the beginning of the 1970s, Jacques Mercier, a researcher at the Centre National de la Recherche Scientifique, Paris, discovered their talismanic drawings. As a result of the encounter, the two Ethiopian scholars decided to become artists as well."[9] In a problematic West-versus-other rhetoric, Martin not only orientalized the creative practices of Gera and Gedewon, but also reinforced an encoded perception of a systematic Euro-American classification. Gera and Gedewon existed as both scholars and artists long before the "Western explorer" Mercier purportedly found them. That non-Western artists had an identity and a place in history "before being discovered by the West" is an ethical issue that many Western curators simply fail to address.

The symbols, drawings and texts of telsem art consist of layers of meanings which require a depth of wisdom. What is clear is that telsem art is a monumental art form where no symbol, drawing, or text can be exhaustively explained. But even for an incomplete and imperfect critical and theoretical perspective, research should engage in the art's intrinsic methodologies, etiquettes, and epistemologies.

Orthodox Christianity and Telsem Art

The interpretation of telsem also varies among artists although most artists agree telsem art is not made by anyone. It has its own rules and customs that only few can decipher. The knowledge is generally transferred to generations by blood lineage. In some cases, painters can achieve exceptional knowledge on their own without being trained by forefathers. But in most cases, the mystery of the knowledge is transferred from one generation to another and only to generation members who can protect the secret. Often telsem is associated with the *debteras* of the Ethiopian Orthodox church though it is also practiced by artists who are not *debteras*. For instance, the telsem artist of this exhibition, Henok Melkamzer, who I exclusively worked with, is not a *debtera*. The *debtera* of the Ethiopian Orthodox church is a learned person who completes the same studies as a priest. However, unlike a priest, he can neither celebrate mass nor take confession because he is also interested in investigating

Untitled, 2023. Acrylic on canvas, 300 x 130 cm

Untitled, 2023. Acrylic on canvas, 300 x 130 cm *Untitled*, 2022. Acrylic on canvas, 300 x 130 cm

non-Christian epistemologies. Known as astrologers, scribes, and fortune tellers, *debteras* perform the music and dance associated with church services. But whether telsem art is practiced by *debteras* or others, the philosophical underpinnings of telsem requires rigorous training in both the spiritual concepts and the visual elicitations of such concepts.

Certainly, the practice of telsem art has also significantly dwindled in recent times. Though formally trained artists from the School of Fine Art and Design at Addis Ababa University continue to emulate the unique styles of telsem art, much of the visual language artists produce lack the deeper framework and knowledge that is imbued in the art since artistic production and pedagogy in the School of Fine Art and Design are centered on the languages of European modernism. At the heart of artists' practice is Ethiopia's unique artistic traditions such as telsem paintings, but without the scope and complexity that comprises the body of knowledge of this tradition.

Furthermore, the rise of evangelism and the current fundamentalist course of the Orthodox Church, which is at the present time trying to violently prohibit any form of non-Orthodox

Untitled (details), 2021. Acrylic on canvas, 60 x 50 cm

Christian belief, has also undermined the mode of telsem's artistic inquiry. Apocryphal texts like the Book of Henok which denounce heresies are often sermonized by the church. According to Gedewon Mekonnen, the Book of Henok reads: "[...] it locates the revelations of the talismans in a world where humans and visible spirits existed side by side, indeed mingled with one another. Ravages resulted and punishment followed, the spirits that escaped were ambushed on every side, and they have been hostile to humans ever since" (Enoch 15:8–16:1).[10]

Certainly, telsem painters had traditionally experienced a dubious relationship with the Orthodox church. At times they were in contradiction with the church which considered them subversive to the faith since telsem art incorporates natural elements and non-Christian spirits and their invisible powers. At other times, their knowledge was widely sought by the church. For instance, artists were pursued to decode difficult texts in Orthodox manuscripts. Artists were erudite in such matters and Orthodox Christianity could not simply erase their powerful knowledge base.

Telsem artists say the genealogy of Ethiopian telsem art dates back to the creation of the universe. They say most of the symbols in telsem art are also appropriated by the Orthodox church. For instance, they say the rectangle that is depicted in telsem appeared long before its portrayal in Orthodox Christian iconography. The rectangle in telsem art represents four eyes symbolizing man, ox, lion, and eagle.

The eagle represents the divine. The eagle is thought to have seven heads that are called seven skies (*sebeatu semayat*). Each layer is imbued with a stage of wisdom and the seventh stage is the highest form of wisdom. Man's ultimate goal is to attain the highest layer of wisdom which is the seventh stage. Unlike the other creations of the world, man with all that

Untitled (detail), 2022. Acrylic on canvas, 300 x 130 cm

god has given him governs all since man is impressed with thought, creativity, and spirituality; *bahre asab, melekote menfes*, and *bahre tebeb*. The lion, which is not afraid of darkness, represents power and majesty and the cow represents kindness and fertility. Here fertility does not only mean procreation but also the cultivability of the land. The ox, which farms the land, is also a symbol of cultivability. But because man is imbued with thought, creativity, and spirituality, man governs all, even the lion. Therefore, man rules both the sky and the earth. Man governs the sky because he first existed as spirit before his material/physical existence. His physical existence is therefore formed with the spiritual existence that he once had. When Orthodox Christianity appropriated the rectangular symbol, however, it transformed the four eyes into the cow to Lucas, the lion to Marcos, man to Mateos (Matthew) and the eagle to Yohannes (John).

The Telsem Art of Henok Melkamzer

As I have indicated elsewhere, the interpretation of the art varies from artist to artist. For instance, Mercier's interpretation of the art was generally conceived from Gedewon Mekonnen and a cleric named Asres who he met in 1974. "I visited Asres daily for several months each year from 1974–1985," wrote Mercier, "making his living as a therapist, he initiated me into his practice and opened his heart."[11]

I exclusively worked with the artist Henok Melkamzer. Most of my interpretations of telsem art and its knowledge base are entirely based on Henok and his father Melkamzer Yehun's account. I have worked with Henok for almost four years and I still do not have a full understanding of telsem art and the knowledge imbued in it. The secrets of telsem's meanings are very well protected through generations. Henok was only able to reveal to me some of the basic knowledges of telsem. He studied his craft from his father and his grandfather. He has no formal training as a painter and never attended the School of Fine Art and Design.

Henok used canvas for the works that were displayed on *Henok Melkamzer: Telsem Symbols and Imagery* although he also paints on parchment on rare occasions. He says he prefers to paint on parchment rather than on canvas. Henok also told me parchments are presently hard to find. He lives in Entoto, close to the Maryam and Raguel churches. His small studio that also serves as his living space has a spectacular view of a forest that is swathed with eucalyptus trees. Entoto was once the capital city for the imperial hold of Menelik II and it is said the emperor brought the eucalyptus seeds from Australia. Permeated with a repetition of words, vines, and numbers, each attribute in Henok's telsem paintings consists of multiple meanings. Posed in unusual forms, the lines are covered in seven basic colors with stunning concoctions. The colors symbolize the seven days of the week and the seven vowels of the Ge'ez script.

He no longer extracts pigments from plants (*eswats*) for his paintings. His recent paintings are made from acrylic rather than *eswats*. He told me extracts from *eswats* deteriorate after five or six years. Indeed, conservation and preservation care in Ethiopia are very rare and even if Henok wanted to preserve the paintings that are made from *eswats*, care for art objects are mostly handled by State-owned cultural institutions for what are considered endangered cultural artefacts.

Certainly, telsem's artistic expression conventionally served as a time-based experience that responded to specific sites and needs. Artists were able to make a living from telsem paintings. The art was born to expire and the ephemeral nature of the object did not really affect the art's monetary value since it was intended to be short-lived. However, in the case of amulets, paintings were covered by leather bindings that protected the image.

Untitled, 2023. Acrylic on canvas, 180 x 110 cm

Untitled, 2022. Acrylic on canvas, 300 x 130 cm

Here it is important to mention Ethiopia's rich illuminated manuscripts that date back to the thirteenth century which are made from *eswats* and which are still intact. Even with the recently discovered two Garima gospels which were created close to the year 500 (one of the gospels is believed to be the earliest Christian manuscript), the images were made from *eswats* and the illuminations are still undamaged. My question to Henok and his father Melkamzer honed on the ephemeral nature of telsem art and why Ethiopia's strong legacy of paint formula did not relate to telsem paintings.

According to Henok and his father, church paintings apply protective layers such as boiled incense. Telsem artists are prohibited to employ protective layers and particularly incense

since the aroma is emblematic of the performative exercise of the Orthodox church. It is believed the aroma of incense can potentially evoke the sensibilities of the church among patrons of telsem art. Artists believe this in turn can possibly reduce the intended potency of the telsem painting. In most cases, the patron is a believer of the Orthodox faith and she/he is always in fear of becoming a *menafik* (nonbeliever) for soliciting service from the telsem artist in lieu of God. And when this uncertainty is conjured all the more by specific reminders of the church such as the aroma of incense, the artist makes sure to avoid such diversion. The aim of the artist is to secure the unwavering attention of the patron.

Henok and Melkamzer also say telsem artists use clean *eswats* (*kebate kelem*) such as blends of *telba* (flax) which they say are no longer found in the urban center. They also say the telsem artworks that are currently in museums are often coated with incense, charcoal or lacquer to protect them from fading. Scholars like Annegret Marx and Claire Bosc-Tiesse have extensively studied paint formulas on Ethiopian icons that date back to the fifteenth century. For instance, Annegret Marx states: "[…] the pigments of the traditional Ethiopian palette are cinnabar, orpiment, ochre, indigo, smalte, green earth and other earths, malachite and madder."[12] But substantive research of paint formulas in century-old manuscripts is still scant and claims about the longevity or lack of different types of *eswats* demand further study. Most people also think of telsem as consisting simply of pendants to be worn around the neck. But telsem was also made into large paintings, similar to the size of the paintings Henok currently creates. These large paintings were hidden inside the patron's roof or hung on her/his wall covered with cotton textile or gauze.

As I have indicated elsewhere, local aesthetic or medicinal interest for telsem has declined, particularly in the urban center since the knowledge base of telsem art is routinely entrenched with the cliched history of the term itself; that of evil spirits and their force. Indeed, Ethiopian values and beliefs which are not consistent with the ideals of a Eurocentric modernity are scorned by the urban elite; a class of nouveaux riches that has recently emerged and that is involved in the buying and selling of art. And the wider perception of modern art which centers its definition in the European tradition has systematically denigrated such types of art as "spiritual," subsequently expelling this form of art from the modernist category and classification. Therefore, Henok's art, which is viewed with a profound uncertainty in its intent, is excluded from the contemporary market and discourse of artistic modernism. Yet there is a booming art market in Addis Ababa today and Henok would like to make a living from his paintings along with other modern artists. But how can this happen when his art is instantly branded as an anthropological artefact? At the center of Henok's concern, thus, lies the complications of the modernist lens. And mediums such as acrylic and canvas offer one explanation as to why Henok has switched from the conventional media of telsem art.

Unless he reconstructs the conventions of telsem paintings in order to situate telsem art in contemporary times, he will never be able to continue his practice. That is also why he would like to solicit exhibiting institutions, collectors and scholars to inject critical value and meaning to telsem art in a formalist modernist reading. This approach will ultimately pronounce the art's inimitable relevance and connection to global modernist projects. Such type of intervention that informs the transition of telsem art from the ethnographic to the aesthetic, from religion to art, will also create and sustain the art's monetary value that in turn will enable the artist to continue to produce.

Untitled, 2021. Acrylic on canvas, 60 x 50 cm

Here it is crucial to note the broader critical and art historical interchange of the last two decades that has increasingly challenged the Western canon of form and aesthetic. The structures of some museums and gallery spaces have significantly transformed to display non-Western art objects within the scope of modernist aesthetic and within the objects' creative parameters albeit in protocols such as video documentation and extensive writing that at times contradict the very essence and intent of the art. However, it is still difficult to convince Western museums and galleries that telsem art is a valid form of modern art since art historical provisions continue to categorize and display telsem art in overtly cliched,

Untitled, 2023. Acrylic on canvas, 60 x 50 cm

oversimplified, and ahistorical narratives. Yet telsem artists continue to negotiate the art's modernist formal properties and its complex cultural configuration within the social realm of the modern world. Despite this paradox, Henok is still producing paintings with a modern consciousness and with a social and intellectual setting that is globally and locally inclined.

The multi-colored lines in Henok's telsem art pause before they secede and yet again mend. But each time they rise, entities that are formed and suggestive emerge as if to explode, all the while presided by the surveying eyes that are aligned in the middle of the canvas. It is the

Untitled (details), 2023. Acrylic on canvas, 300 x 130 cm

eye that looks, that is curious, that guards and that surveils. "The key to reading telsem," says Henok, "is to begin from the center... the eyes are at the center... and move outwards. And each vine begins with a word or spiritual concept to depict the complex relationship between color and the alphabetical form of telsem language."

"To understand the basic meaning of telsem," say Henok and his father, "the composition should include the following:"

1. Ge'ez alphabet (*fidel*)
2. Vines and colors (*hareg, kelem*)
3. The face
4. Numbers
5. The thirteen months of the Ethiopian calendar

The Alphabet (*fidel*)
The Ge'ez alphabet consists of 26 consonantal letters and seven vowels for each letter. For instance, if we take the first letter ha, the vowels are: *ha geez, hu kayb, hi sals, ha rabee, hea hames, hee sades, ho sabe'e* (ha1, hu2, hi3, ha4, hea5, he'e6 and ho7).

Vines and Colors (*hargeoch, kelemoch*)
According to Henok and Melkamzer Yehun, vines are symbolic of fundamental forces that weave the human race together. Human beings and the planet come together through the creative force of vines that are interconnected and intertwined. They are constantly in conversation with each other. And these vines consist of names and shapes which can be read

Henok Melkamzer: Telsem Symbols and Imagery

Untitled (details), 2022. Acrylic on canvas, 60 x 50 cm

and explained. The emotive representation of the vines come to light through color. The colors are made from *eswats*—now acrylic—and the earthen color of the soil. Colors also consist of seven different shades that represent the seven vowels of the Ge'ez alphabet and the seven days of the week. And each color represents a form of the physical and spiritual life.

The Face
Henok and Melkamzer Yehun also say the face has a critical meaning in telsem paintings. Not only does the face represent the image of the human, it also embodies the images of nature and the spirits that personify nature. The good, the beauty, the strength, and transparency of nature are also represented through the face.

Numbers
The meaning of numbers is also critical to telsem. Numbers serve to assess the woven characteristics of the human and nature. Distinct calculations which are secretly protected are used to understand illnesses, fortitudes, and calamities, or any other query that the artist provokes.

The Thirteen Months of the Ethiopian Calendar
There are thirteen months in the Ethiopian calendar, twelve of each have thirty days. Pagume, which is the last month, consists of five days and six days during a leap year. However, in telsem paintings Pagume has seven days. Therefore, telsem uses 367 instead of 365 days with 367 different shapes and colors. Henok and his father say there is one alphabet for each month; ranging from Meskerem (the first month) to Pagume (the last month). The alphabets are constructed as pictures that are influenced in both physical terms and in spiritual manifestations that derive from each script. And each month involves 29 variations of the principal form to represent each day of the month.

Untitled (details), 2022. Acrylic on canvas, 60 x 50 cm

The span from Meskerem (the first month) to Hedar (the third month) is called *Tsedey*, which means windy in the Ge'ez script. The span from Hedar to Megabit (the sixth month) is called *Mesew*, which means a combination of wind and sun in Ge'ez. And the span from Megabit to Sene (the ninth month) is called *Hagai*, which means dry in Ge'ez, while from Sene to Pagume, it is called *Kremt*, which means wet.

The months also represent the following:

1.	Meskerem	balance
2.	Tekmet	water
3.	Hedar	chaos or fire
4.	Tahesas	Earth or the earth in the desert
5.	Ter	wind
6.	Yekatit	ocean or water of the ocean
7.	Megabit	fire that is not chaotic
8.	Meyazya	settled earth
9.	Genbot	changing way or tide
10.	Sene	dam or water that is contained
11.	Hamle	flame that is ready to extinguish
12.	Nehase	a pit
13.	Pagume	the end of the world or the beginning of new or the new year

from the stars which appear for each month that the artist determines the course of the painting; its vines, lines and symbols. Knowledge in cosmology is crucial for the telsem artist. For instance, the artist uses several calculations to align the patron's birthdate and her/his

mother's birthdate with the stars that appear on those dates to finally establish an appropriate zodiac. Several numbers are interposed for calculation which the artist does not reveal. One field of study that telsem scholars also explore are the foundational principles of the ecology and its multifaceted relationship to humanity. Scholars are urged to critically understand the physical and moral nature of their own sensibility to the ethics, geographies and philosophies of nature. By that I mean the different essence of the plant that is also used for color, its relationship to sunlight, its composition in relation to other plants, its contribution as medicine and its aroma. By the sentiments of this receptivity, telsem artists/scholars unceasingly commune with questions of truth that originate from the divine, the non-divine, animals that populate the environment, the stars, the fauna and flora, and many more. The forces of nature in all its form, hence, dictate what ultimately transpires as image. In this regard, scholars' sensation is intimately linked to the art and science of the environment and its natural source which makes the telsem artist unquestionably modern.

The vines, numbers, and alphabets are specifically learnt and strategically formulated in ways in which each vine, number and text address and identify specific problems. Therefore, each telsem painting has its own story.

Conclusion

Despite a recent limited attention to its rich source of knowledge, telsem art continues to be practiced in contemporary times not only in the rural areas but also in the urban centers. Artists are recreating the old tradition of telsem in its contemporary lived consequence; an art form that covers different aims and narratives than its preceding history through its encounters with the contemporary moment.

Looking into the knowledge of telsem from within and in its own terms, the exhibition *Henok Melkamzer: Telsem Symbols and Imagery* examines the spiritual and abstract features of Ethiopian telsem art to signify a medium of consciousness in which knowledge can also be explored beyond its rational domain into the spiritual realm. It also points to the multiple and shifting ways in which spiritual practices are formed and are in turn shaped by their modern secular contexts. Indeed, secularity has been the organizing principle of Western modernity but as anthropologist Talal Asad has shown, the West's secularization thesis has depended on Western presumptions that claims religion is a universal experience that is distinctly different from culture. "It is this assumption," says Talal Asad, "that allows us to think of religion as 'infecting' the secular domain."[13]

Taking Asad as a point of departure, I would like to emphasize the distinct spiritual practice of telsem art that is inescapably connected to its lived experience and culture; in this case it is intertwined with its lived modern culture from which the art object emanates, and in which the religious and the secular appear in sophisticated ways. One theme that continually stand out in my interrogation of Ethiopian modernism is its contingency to "tradition." Artists' claim of the past is not intended to depict an unchanging truth in homogenous time. But as Asad argues, it is rather a method to modify, discard, select, or reproduce "tradition" within "tradition's" multiple temporalities. It is in this regard that I believe telsem art should be viewed and examined; as an artistic practice that originates from a long history of tradition that is still practiced and, hence, an art form that should be rearticulated as a modernist intervention.

[1] Okwui Enwezor, "Topographies of Critical Practice: Exhibitions as Place and Site," in *The Exhibitionist*, https://anagrambooks.com/the-exhibitionist-no-2
[2] Ibid.
[3] Ibid.
[4] Timothy Mitchell, "The Stage of Modernity," in *Questions of Modernity* (Minneapolis: University of Minnesota Press, 2000), 7.
[5] Talal Asad, *Formations of the Secular, Christianity, Islam, Modernity* (Stanford: Stanford University Press, 2003), 13.
[6] Holland Cotter, "Not Just for Viewing, But Also for Healing Art", in *The New York Times*, February, 14, 1997.
[7] Jacques Mercier, *Art that Heals. The Image as Medicine in Ethiopia*, New York: The Museum for African Art/Prestel, 1997, 60.
[8] Ibid., 115.
[9] Jean-Hubert Martin in *Art that Heals*, https://apexart.org/exhibitions/martin.php
[10] Jacques Mercier, *op. cit.*, 48.
[11] Jacques Mercier, *op. cit.*, 60.
[12] Annegret Marx, "Ethiopian Icons," https://www.academia.edu/18276782/Ethiopian_Icons?email_work_card=view-paper
[13] Talal Asad, *op. cit.*, 16.

በስመ፡እግዚአ
ብሔር፡ወመፈቅ
ድስ፡ሩአምላክነ
ዛንቱ፡መጽሐፍ
ይትነበበ፡እምት
ዕሙዳን፡በመ
ጽሐፈ፡ተአምረ፡
ለእግዚእትነ፡ቅ

ትንግልሃዊ
ርሃሙ፡ወሰ
ይሳክቆግር
ጸሐፈ፡ግር
ዘወጽአመ
፡ማርቆስ
ለያ፡እመከነ
ርታ፡ዘምስር

Untitled (detail), 2018. Acrylic on canvas, 240 x 84 cm. Anonymous Collection

Henok's World of Telsem[1]

Semeneh Ayalew Asfaw

Telsem is a Ge'ez word which literally means to paint, to write. According to the living bearers of the tradition, it refers to an age-old knowledge system that is said to have existed since the beginning of the world. They say, telsem is given to humans by God to understand nature and to help clarify and deal with "the density" and vicissitudes of life. While the purpose and function of telsem in Ethiopia is multifaceted and wide-ranging, Henok, the artist whose works are presented in this exhibition, claims there were four major areas where the knowledge of telsem was historically applied. These were: art, healing, agriculture, and war. For him, the knowledge of telsem can, however, be extended to other fields of knowledge including astronomy, climate science, technological sciences, among others.

Though telsem is considered God given, the body of knowledge contained in it is also accumulated across the ages, through observation and investigation as essential methodologies of inquiry. As the art historian and the curator of this exhibition, Elizabeth W. Giorgis argues, "Drawing from astrology, religion and spirituality, the Ethiopian art form of telsem interweaves symbols, drawings and texts imbued with spiritual and philosophical significance. Shaped throughout the ages by the socio-political and cultural histories of Ethiopia, telsem—with its ancient inspirations and modern idioms—[could be] used to address critical problems in the contemporary world such as climate disasters, war and poverty." Despite such positive appraisal of telsem, as an art form and a system of knowledge, however, the idea that telsem is magic seems to be more enduring. The perpetuation of this assumption has had far reaching implications not only on modern institutions of knowledge but also the Ethiopian Orthodox church that it has been associated with. The supposition that telsem seeks knowledge about nature through mysterious and esoteric means or techniques (by mobilizing supernatural forces, summoning malign spirits), not only delegitimizes telsem but also precludes interest and initiative to study and understand its intricate artistic motifs, the proficiency of its techniques as well as the knowledge and expertise that goes into its healing practices. For example, healing in telsem or telsem art that uses plants for color requires enormous knowledge about plants. These practices rely on the "teaching" of plants and trees, the nature of the fauna, the changes and circulation of the seasons as well as the relationship of the earth, its resident beings and its seas with celestial bodies.

One of the corner stones of telsem as an art form involves the use of a calendar system that applies numerical calculations, as its framework, in the process of procuring paintings on parchment scrolls (as historically done) or canvases (as artists such as Henok do). The zodiacal tradition used in telsem art distinguishes itself from the calendar that is used by the Ethiopian Orthodox Tewahedo church. While the church's calendar has 12 months with 30 equal days and an intercalary month with five or six days (Pagume) at the end of the year, Pagume has seven (instead of five or six days) in the telsem calendar. Hence, in this calendar, a year contains 367 days, and Pagume (the thirteenth month) has seven days, while the other 12 months have 30 equal days. Even if this slight difference might sound insignificant for the uninitiated, the implications of this calculation to the interpretation and symbolism of telsem is substantial. Telsem artists and practitioners insist that both the symbolic tropes in telsem art, as well as its calendar, predate the calendar and the knowledge traditions of the Ethiopian Orthodox Tewahedo church. Moreover, in the telsem calendar, numerical calculations are key to understand the impact of the Sun and the stars on earthly life as well as the relationship between creation. According to Henok, Pagume is the month where all creation occurred, it is "the gear that turns the wheels of Time." Pagume is central to understanding the semiotic structure of the telsem calendar and Henok's art works are based on the calculations of this calendar. The telsem calendar uses the four basic elements of life (Earth, Air, Fire, and Water) to represent and distinguish the months of the year. Even if telsem's zodiac resembles other zodiac traditions (such as the Babylonian or Greek, which have 12 equal months and 12 signs), it is distinctive in its purpose. Henok claims that the

Untitled, 2021. Acrylic on canvas, 60 x 50 cm

Untitled, 2021. Acrylic on canvas, 60 x 50 cm

Untitled, 2022. Acrylic on canvas, 60 x 50 cm

most significant difference is, while stars determine individual fate and destiny in the Greek and Babylonian astronomy, the signs of the zodiac in telsem only serve as forewarnings that prime individuals from an incoming threat—spiritual or worldly. Rather than scripts of divination that preordain life on earth, the main purpose of telsem art (that is based on the zodiac star signs) is to protect individuals or family members from harm. Telsem parchment scrolls were hanged in individual homes or worn as amulets to ward off evil or to guard oneself from losing the gifts of creation (wisdom, health and wellbeing, knowledge, fortitude, and so on).

The Semiotic Foundations of Telsem Art and Henok's Account of Time
For telsem to exist, as an art form, knowledge of five basic elements is necessary—knowledge of the Ge'ez alphabet (*fidel*), number (*qutir*), image or face (*melk*), color and vine (*qelem, hareg*), and the thirteenth-month telsem calendar. Every alphabet

is representable with a numerical base. While number is a formula or equation used to represent the affiliation and intimacy between human beings and nature, vines are used to show the relationship between creation (human beings, stars, plants, and so forth). And the various colors in which vines appear in telsem paintings express the nature of these relationships and invest a particular meaning to them. Image or face is a representation of human beings, animals, or spiritual bodies. As an astronomical system where creation, and their relationships to one another are represented, the calendar and the zodiac system serve as a measurement device through which telsem art comes to being. Telsem is, hence, a color-rich, emotionally and aesthetically alluring art form and composition, infused with meaning-laden symbols and motifs that express the relationship of celestial bodies with human beings. In addition to its aesthetic appeal and emotional stimulation, it is also an art that is made for a purpose—to protect and guard individuals from the avarice of life.

In this exhibition, Henok employs all the above discussed elements of telsem art to give us over hundred nineteen artworks. In these works, Henok's main preoccupation is Time. He says, "I am interested in telling the story of Time, the grandmaster." As an exhibition dealing with the subject of time, a level of familiarity with the telsem zodiac might prove useful in reading these collections. The telsem zodiac is a ring that contains 13 signs with 13 corresponding months of the year, with Pagume being the unique month of creation. The calendar depicts the relationship between the Sun and the Earth, and the constellation of stars that appear on earth's sky. Every month has its own particular name and corresponding sign,[2] and each month of the year, with the exception of Pagume, is signified by either of the four basic elements (that are found in various states) of nature—Fire, Earth, Air, and Water. Meskerem, the first month of the year, is an air sign that represents balance, Tekemt (the second) water, Hidar (the third) fire, Tahesas (the fourth) dry earth, Tir (the fifth) violent wind/hurricane, Yekatit (the sixth) the ocean's water, Megabit (the seventh) moderate wind, Miazia (the eighth) settled earth, Ginbot (the ninth) wind that changes way, Sene (the tenth) water that is contained, Hamle (the eleventh) latent fire that extinguishes, Nehassie (the twelfth) deep earth or pit. Consequently, the 13 signs of the zodiac that correspond to the 13 months of the year are comprised of 367 days, to each of which a particular color and image are attached.

Henok's visual account of time is, therefore, told in this collection of paintings, based on the organizing idea that Pagume, the thirteenth and the last month of the year with the fewest days is "the gear that turns the wheels of time." While Pagume has only seven days, it is the month when all creation occurred. In the telsem calendar Pagume is the month that serves as the foundation on which all life is built. It is the key to understand the movement of Time. It is apparent that in telsem iconography, Pagume is a month like no other—as it is the month that holds two opposites as equal truths—the month on which the world came to being and the month when it will come to an end. It is in the seven days of Pagume that all creation came to being and then multiplied in the years since, to populate the world and the universe. The primal importance of Pagume is hence key to grasp Henok's artistic imagination.

If Pagume appears in Henok's artistic expression as the signpost of the wonders of God's creation,[3] and of his grand design, then in the account of the rest of the 12 months, Henok seems to be interested more in showing what humans have made of the pattern of relations between God's creation.

The Pedagogy of Telsem

As stated in the beginning of this essay, one of the central ideas of telsem as a body of knowledge and an art form is that telsem is given to humans by God to understand the densities of life and nature. The Eye—one of the most common elements that appears in telsem paintings—is a representation of the omnipresence of God, and a testament to the idea that God is the source of everything. As Elizabeth W. Giorgis notes, "It is the eye that looks, that is curious, that guards and that surveils. [...] The key to reading telsem [...] is to begin from the center [...] the eyes are at the center—and move outwards." While the Eye of God is omnipresent and is the eye that guides, human beings are also gifted with the capacity to inquire, investigate, observe, and study the nature of things. As Henok says, "everything is knowable, except the breath of life (*estinfas*)." While Conception (the breath of God that gave life to all creation) is not knowable, everything else is. In this sense, humans are able to gain knowledge not just about the nature of things in the physical world but also in the spirit world. Henok says, "even God is accessible through his creation", as His nature is revealed through the things he brought to existence. While the breath of life (*estinfas*) is beyond human comprehension, and is thus the foundation and subject of belief and faith (as opposed to knowledge), nature and all other creation

Exhibition view

is searchable, knowable, and thus could be put to investigation and inquiry. Indeed, telsem practitioners gain knowledge through the use of mathematical methods (in paintings and astronomy), the study and investigation of the property and nature of plants (as medicine), observed and studied the relationship between creations (astrology and art) show that self-application is a key means to acquire knowledge.

Accordingly, Telsem is neither "magic" that relies exclusively on the use of the mysterious, and the occult, to determine the properties of the natural world, nor is it science that relies wholly on the examination of the nature of the physical world, to gain knowledge about the world. As Henok insists, telsem's methods and its accumulated knowledge on plants, animals, medicine, agriculture, and astronomy, as well as its ways of knowing are relevant to our time and can be in the service of the spiritual and material balance and flourishing of life. Despite its definition as a relic and dreg from the past, a timeworn tradition "now on the wane," Telsem's wealth of knowledge in various fields of inquiry and ways of knowing could be excavated to address pressing issues of our time. The goal of telsem in-depth study, therefore, should go beyond the preservation of an ancient knowledge system, and could be employed to address problems of our contemporary life. The crisis in the truth regime of our time, the ecological devastations, and the economic and moral impoverishment of human society, and a gnawing sense of cultural disenchantment in various quarters of the world, call for greater attention to be given to ways of knowing and knowledge systems such as telsem that have hitherto attracted little academic attention. Studying the various dimensions of telsem, its intricate and refined artistic tropes, its semiotic structure, its knowledge of plants (*etsewat*) for health, mental activation, and wellness, its mathematical methods, its knowledge of agriculture and the climate, its astronomic and calendar system might help us appreciate the significance of telsem to contemporary life. Telsem, and other ways of knowing that have long seemed antiquated might help us see and understand the problems of the world differently, providing *another* language and grammar. Telsem as a knowledge system, and Henok's artistic renditions of it, complicates, upsets and "jeopardizes" the secular/spiritual and modern/traditional divide by trespassing the boundaries supposedly existing in these different forms of knowledge.[4]

Telsem considers both the natural and the transcendental as knowable. In this sense it rejects the notion that "what we can know and apprehend is only the natural and the physical world." It investigates all creation—both the physical and the spiritual world—to gain knowledge about them. On the one hand, in telsem, even the spirit world is not considered as something hidden, and beyond human comprehension. On the other hand, mathematical methods and formulas are used to understand the movement of the seasons, the motion of the seas, and the relationship of celestial bodies with life on earth. Hence, while Telsem draws on religion, spirituality and astrology, its concerns also go beyond the spiritual, the divine, and the transcendental. It also seeks to address human material concerns such as the sustenance, protection, and nourishment of life. Its knowledge of the seasons has been used to aid agriculture, and its numerical calculations are part of its artistic endeavor, while

its knowledge about plants has been part of its healing practice. In telsem cosmology, the spiritual (transcendental) world, and the natural world are seen as conjoined, and hence, the acquisition of knowledge of one, without or in separation from the other, is not thinkable. The transcendental and the natural world are connected and are both considered the key to knowledge about human life and the physical world. Knowledge about nature could not be comprehended just by investigating one over the exclusion of the other. The spiritual dimension of our being, and the natural dimension of life must be brought together to understand the origin and nature of being. In this sense, telsem is a way of knowing that works with the assumption that the spiritual and the material dimension of lifeforms and things are intertwined, and one cannot be disconnected from the other. Knowledge is gained both through the lessons of nature—by studying the rhythm of life and creation (by observing and investigating the motion of the trees, animals, the land, the seas, and the skies), as well as through spiritual yearning and inspiration. In this sense, telsem could be considered a knowledge system that is based on the notion of immanence—where the transcendental is present in the natural world. Its lesson to us is perhaps a more balanced, coherent, and deeper understanding of human life, and our place in this planet is acquired by gaining knowledge of the natural world, while at the same time investigating the transcendental. The crisis of our contemporary world—war, ecological calamities, impoverishment, political instability, and a sense of cultural disenchantment, perhaps requires an exploration into such pedagogies and epistemes outside the Western-centric one that dominates our present world.

Page 50
Henok Melkamzer in his studio, Entoto, Addis Ababa, Ethiopia, 2023

[1] This essay grew out of conversations with Henok Melkamzer, in August 2023.

[2] Similar to the telsem calendar that has 13 zodiac signs, recent astronomical calculations have shown that the Earth passes through 13 (instead of 12) zodiac signs (each representing a constellation of stars) as the Earth follows its own orbit to complete its revolution around the Sun. According to NASA, "[…] the zodiac signs are […] constellations that are in line with the Earth and the Sun as the planet follows its orbit. Earth actually travels through 13 signs […], but some 3000 years ago the Babylonians […] decided 12 was neater than 13, so excluded the 13th zodiac sign and divided the zodiac into 12 parts based on the 12 months of their calendar." Melissa Locker, in *The Time*, 17 July 2020, in https://time.com/5867647/nasa-zodiac-star/

[3] According to the telsem zodiac, it was in Pagume that God declared "Let there be Light." "In the beginning was the Word, and the Word was with God, and the Word was God. He was with God in the beginning. Through him all things were made; without him nothing was made that has been made. In him was life, and that life was the light of all mankind. The light shines in the darkness, and the darkness has not overcome it." John 1:1 of The New Testament.

[4] Insight taken from my conversation with Serawit Bekele Debele.

Henok's World of Telsem

Works

Untitled, 2022. Acrylic on canvas,
60 x 50 cm

Untitled, 2022. Acrylic on canvas,
60 x 50 cm

Untitled, 2022. Acrylic on canvas,
60 x 50 cm

Untitled, 2022. Acrylic on canvas,
60 x 50 cm

52 Works

Untitled, 2021. Acrylic on canvas, 60 x 50 cm

Untitled, 2021. Acrylic on canvas, 60 x 50 cm

Untitled, 2023. Acrylic on canvas, 60 x 50 cm

Untitled, 2023. Acrylic on canvas, 60 x 50 cm

Untitled, 2023. Acrylic on canvas, 60 x 50 cm

Untitled, 2023. Acrylic on canvas, 60 x 50 cm

54 Works

Untitled, 2023. Acrylic on canvas, 60 x 50 cm

Untitled, 2022. Acrylic on canvas, 60 x 50 cm

Untitled, 2023. Acrylic on canvas, 60 x 50 cm

Untitled, 2022. Acrylic on canvas, 60 x 50 cm

Works

Untitled, 2023. Acrylic on canvas, 60 x 50 cm

Untitled, 2022. Acrylic on canvas, 60 x 50 cm

Untitled, 2023. Acrylic on canvas, 60 x 50 cm

Untitled, 2022. Acrylic on canvas, 60 x 50 cm

Untitled, 2022. Acrylic on canvas, 60 x 50 cm

Untitled, 2023. Acrylic on canvas, 60 x 50 cm

Untitled, 2023. Acrylic on canvas, 60 x 50 cm

Untitled, 2022. Acrylic on canvas, 60 x 50 cm

Works

Untitled, 2022. Acrylic on canvas,
60 x 50 cm

Untitled, 2022. Acrylic on canvas,
60 x 50 cm

Untitled, 2022. Acrylic on canvas,
60 x 50 cm

Untitled, 2022. Acrylic on canvas,
60 x 50 cm

Works

Untitled, 2021. Acrylic on canvas,
60 x 50 cm

Untitled, 2021. Acrylic on canvas,
60 x 50 cm

Untitled, 2022. Acrylic on canvas, 60 x 50 cm

Untitled, 2023. Acrylic on canvas, 60 x 50 cm

Untitled, 2023. Acrylic on canvas, 60 x 50 cm

Untitled, 2022. Acrylic on canvas, 60 x 50 cm

Untitled, 2021. Acrylic on canvas, 60 x 50 cm

Untitled, 2023. Acrylic on canvas, 60 x 50 cm

Untitled, 2022. Acrylic on canvas, 60 x 50 cm

Untitled, 2023. Acrylic on canvas, 60 x 50 cm

Works 61

Untitled, 2022. Acrylic on canvas, 60 x 50 cm

Untitled, 2022. Acrylic on canvas, 60 x 50 cm

Untitled, 2022. Acrylic on canvas,
60 x 50 cm

Untitled, 2022. Acrylic on canvas,
60 x 50 cm

Untitled, 2021. Acrylic on canvas,
60 x 50 cm

Untitled, 2021. Acrylic on canvas,
60 x 50 cm

Works

Untitled, 2021. Acrylic on canvas, 60 x 50 cm

Untitled, 2021. Acrylic on canvas, 60 x 50 cm

Untitled, 2022. Acrylic on canvas, 60 x 50 cm

Untitled, 2022. Acrylic on canvas, 60 x 50 cm

Untitled, 2022. Acrylic on canvas, 60 x 50 cm

Untitled, 2022. Acrylic on canvas, 60 x 50 cm

Untitled, 2022. Acrylic on canvas,
60 x 50 cm

Untitled, 2022. Acrylic on canvas,
60 x 50 cm

Untitled, 2022. Acrylic on canvas,
60 x 50 cm

Untitled, 2022. Acrylic on canvas,
60 x 50 cm

Untitled, 2021. Acrylic on canvas,
60 x 50 cm

Untitled, 2021. Acrylic on canvas,
60 x 50 cm

Untitled, 2021. Acrylic on canvas, 60 x 50 cm

Untitled, 2021. Acrylic on canvas, 60 x 50 cm

Untitled, 2021. Acrylic on canvas, 60 x 50 cm

Untitled, 2021. Acrylic on canvas, 60 x 50 cm

Untitled, 2021. Acrylic on canvas, 60 x 50 cm

Untitled, 2021. Acrylic on canvas, 60 x 50 cm

Works 75

Untitled, 2023. Acrylic on canvas, 60 x 50 cm

Untitled, 2022. Acrylic on canvas, 60 x 50 cm

Untitled, 2023. Acrylic on canvas, 60 x 50 cm

Untitled, 2023. Acrylic on canvas, 60 x 50 cm

76 Works

Untitled, 2023. Acrylic on canvas, 60 x 50 cm

Untitled, 2021. Acrylic on canvas, 60 x 50 cm

Untitled, 2023. Acrylic on canvas, 60 x 50 cm

Untitled, 2021. Acrylic on canvas, 60 x 50 cm

Untitled, 2023. Acrylic on canvas, 60 x 50 cm

Untitled, 2023. Acrylic on canvas, 60 x 50 cm

Untitled, 2023. Acrylic on canvas, 60 x 50 cm

Untitled, 2023. Acrylic on canvas, 60 x 50 cm

Untitled, 2023. Acrylic on canvas, 60 x 50 cm

Untitled, 2021. Acrylic on canvas, 60 x 50 cm

Untitled, 2022. Acrylic on canvas, 60 x 50 cm

Untitled, 2022. Acrylic on canvas, 60 x 50 cm

Untitled, 2023. Acrylic on canvas, 60 x 50 cm

Untitled, 2021. Acrylic on canvas, 60 x 50 cm

Untitled, 2023. Acrylic on canvas, 60 x 50 cm

Untitled, 2023. Acrylic on canvas, 60 x 50 cm

82 Works

Untitled, 2021. Acrylic on canvas, 60 x 50 cm

Untitled, 2022. Acrylic on canvas, 60 x 50 cm

Untitled, 2022. Acrylic on canvas, 60 x 50 cm

Untitled, 2021. Acrylic on canvas, 60 x 50 cm

Untitled, 2021. Acrylic on canvas, 60 x 50 cm

Untitled, 2021. Acrylic on canvas, 60 x 50 cm

Untitled, 2018. Acrylic on canvas, 240 x 84 cm. Anonymous Collection

Untitled, 2018. Acrylic on canvas, 240 x 84 cm. Anonymous Collection

Untitled, 2022. Acrylic on canvas, 300 x 130 cm

Untitled, 2023. Acrylic on canvas, 200 x 100 cm

Untitled, 2023. Acrylic on canvas, 133,5 x 54 cm. Courtesy of Sataan Al-Hassan

Untitled, 2023. Acrylic on canvas, 200 x 100 cm

Untitled, 2022. Acrylic on canvas, 300 x 130 cm

Untitled, 2020. Acrylic on canvas, 184 x 124 cm. Courtesy of The Africa Institute

Untitled, 2022. Acrylic on canvas, 138,5 x 133,5 cm. Courtesy of Surafel Wondimu Abebe

Untitled, 2023. Acrylic on canvas, 300 x 130 cm

Untitled, 2022. Acrylic on canvas, 180 x 120 cm

Untitled, 2021. Acrylic on canvas, 180 x 120 cm

Untitled, 2021. Acrylic on canvas, 180 x 120 cm

Untitled, 2022. Acrylic on canvas, 180 x 120 cm

Untitled, 2023. Acrylic on canvas, 180 x 110 cm

Untitled, 2023. Acrylic on canvas, 300 x 130 cm

Untitled, 2022. Acrylic on canvas, 300 x 130 cm

Untitled, 2023. Acrylic on canvas, 300 x 130 cm

Untitled, 2023. Acrylic on canvas, 300 x 130 cm

Untitled, 2023. Acrylic on canvas, 300 x 130 cm

Untitled, 2023. Acrylic on canvas, 300 x 130 cm

Untitled, 2022. Acrylic on canvas, 300 x 130 cm

Untitled, 2023. Acrylic on canvas, 300 x 130 cm

Untitled, 2022. Acrylic on canvas, 180 x 120 cm

Untitled, 2022. Acrylic on canvas, 300 x 130 cm

Untitled, 2022. Acrylic on canvas, 300 x 130 cm

Untitled, 2023. Acrylic on canvas, 300 x 130 cm

Untitled, 2022. Acrylic on canvas, 300 x 130 cm

Untitled, 2023. Acrylic on canvas, 300 x 130 cm

Works

Works 125

Works

Works

Works

Works

Works

Works

Works

Works

Works

Works

Works

Sharjah, 2024. Acrylic on canvas, 200 x 200 cm

Artist Biography

Henok Melkamzer (b. 1975) lives and works in a studio on Mount Entoto in Addis Ababa. Henok studied telsem in a monastery in Bahir Dar, Ethiopia, for 16 years alongside learning the intricacies of the practice firsthand from his father and grandfather, who were both telsem healers. Henok maintains an intimate interest in preserving telsem within his community and bringing the art form to new audiences.

Henok has showcased his work in both solo and group exhibitions in Ethiopia and internationally. His most recent solo exhibition *Men Neber* (2018) was presented at the Modern Art Museum in Addis Ababa. A commissioned artist for the Second Lahore Biennial (2020) and a participant in the conference *Ethiopia: Modern Nation – Ancient Roots* (2022) at The Africa Institute, Sharjah, Henok has attained international acclaim as a proponent of telsem and an advocate for his cultural heritage.

Authors Biographies

Julie Mehretu
Julie Mehretu (1970) is a world-renowned painter, born in Addis Ababa, Ethiopia, who lives and works between New York City and Berlin. She received a Master of Fine Art with honors from The Rhode Island School of Design in 1997. Mehretu is a recipient of many awards, including The MacArthur Award (2005) and the US Department of State Medal of Arts Award (2015). She has exhibited extensively in international and national solo and group exhibitions and is represented in public and private collections around the world. Her recent projects include completing two large-scale paintings for the San Francisco Museum of Modern Art's Evelyn and Walter Haas, Jr. Atrium in September 2017, entitled *HOWL, eon (I, II)*. Her recent exhibitions include the Venice Biennale (2019) and a mid-career survey at the Los Angeles County Museum of Art, which traveled to The Whitney Museum of American Art in New York (2020), High Museum in Atlanta (2020), and The Walker Art Center in Minneapolis (2021). She is a member of the American Academy of Arts and Letters and is represented by Marian Goodman Gallery, New York.

Semeneh Ayalew Asfaw
Semeneh Ayalew Asfaw is a student of history whose areas of interest include revolution, social protest, social and cultural change in the history of Ethiopia. He is currently a research fellow at The Africa Institute, Sharjah.

Elizabeth W. Giorgis

Elizabeth W. Giorgis received her Ph.D. in the History of Art and Visual Studies from Cornell University and her Masters in Museum Studies from New York University. She served as the director of the Institute of Ethiopian Studies, the dean of the College of Performing and Visual Art, and the director of the Modern Art Museum: Gebre Kristos Desta Center at Addis Ababa University. She is the author of several publications and a member of the editorial board for *Transition Magazine*, *Northeast African Studies* journal (NEAS), *ARTMargins*, *Critical African Studies*, and the Ethiopian Journal of Social Science and Humanities (EJOSSAH). She is also an advisory editorial board member for the *Journal of African History*, *Journal for Critical African Studies* (JCAS), *Callaloo*, and contributing editor for *Comparative Studies of South Asia, Africa, and the Middle East* (CSSAAME).

She is a recipient of several fellowships including The Ali Mazrui Senior Fellowship for Global African Studies at The Africa Institute, a Distinguished Visiting Scholar at Brown University, a Visiting Professor at the Academy of Fine Art in Vienna, and a fellow at the Rockefeller Bellagio Center Resident Fellows Program in Italy. Her book, *Modernist Art in Ethiopia* (2019, Ohio University Press), stands as the first comprehensive monographic study of Ethiopian visual modernism, situated within a broader social and intellectual context. Shortlisted for the African Studies Association UK Fage and Oliver Prize and a finalist for the African Studies Association Best Book Prize, it ultimately secured the African Studies Association's 2020 Bethwell A. Ogbot Book Prize for the best book on East African Studies.

She served as a faculty member for MAHASSA (Modern Art Histories in and across Africa, South and Southeast Asia), a Getty foundation grant, held in Hong Kong in August 2019 and in Dhaka, Bangladesh, in February 2020. In January 2019, she served as convener for the first African Humanities Initiative called *Africa as Concept: Decolonization, Emancipation and Freedom*, which was sponsored by the Mellon Foundation and the Consortium of the Humanities, Centers and Institutes (CHCI).

She has curated several exhibitions at the Modern Art Museum: Gebre Kristos Desta Center, more recently, the works of Icelandic–Danish artist Olafur Eliasson. She has also participated in several international conferences and public lectures.

Exhibition Credits

This book was published on the occasion of the exhibition

**Henok Melkamzer:
Telsem Symbols and Imagery**
24 February – 16 June 2024
Sharjah Art Museum
Arts Area, Al Shuweiheen
Sharjah Art Foundation
United Arab Emirates

Organized by
Sharjah Art Foundation
in collaboration with
The Africa Institute, Sharjah
and
Sharjah Museums Authority

Curated by
Elizabeth W. Giorgis
with Amal Al Ali

Spatial Design by
Sarra Elomrani

Sharjah Art Foundation
President and Director
Hoor Al Qasimi

Vice President
Nawar Al Qassimi

Curatorial
Jiwon Lee
Amal Al Ali

Learning and Research
Noora Al Mualla
Aisha Kidwai, Alaa Amin, Hessa Al Ajmani, Huda Hammad, Jinan Coulter, Lama Altakruri, Manal Al Mutawa, Sana Abdulmajeed, Shirin Najjar

Operations
Eng Hasan Ali Mahmoud Al Jaddah
Sarra Elomrani
Abdu Rahiman Mavilakandy, Abid Amir Khan, Khaled Samy Elsawy, Mohamed Khan Mera, Moustafa Kandil, Sameer Koothungal, Shuaib Poonthala

Press and Marketing
Alyazeyah Al Marri
AbdulHalim Elzein, Ali Mrad, Ghaith Khoury, Hind Thaloob, Hoda Amini, Joseph dela Cerna, Muna Al Ansaari, Salma Farzaneh, Yalda Bidshahri

Design and Multimedia
Dima Bittard
Aman Darwish, Magdi Tawfig, Mohammed Ameer, Motaz Mawid, Shafeek Nalakath Kareem, Shaikha Al Maazmi, Shanavas Jamaluddin, Unnikrishnan Suresh, Ward Helal

Editorial and Content Strategy
Jyoti Dhar
Kamayani Sharma, Kathleen Butti, Mahshid Rafiei, Rajwant Sandhu, Rosalyn D'Mello

Arabic Editorial and Translation
Ismail Alrifaie
Abdullah Hussein, Mohamad Al Saadei, Ziad Abdullah

Hospitality
Najeeba Aslam
Kassem Almukdad, Shaima Hussain

Guest Relations
Zahra Al Hassan
Hajer Bulahbal, Ibrahim Ahmed, Maryam Amini, Omar Al Obeidli

Guides
Abdullah Alshamsi, Ahmed Ali, Ahmed Hussain, Ahmed Mohammed Ali, Ayoub Arbaoui, Hassan Aljasmi, Ibrahim Ismail, Khalifa Sultan, Loiy Masoud, Mahmoud Hatem, Moza Ali, Naser Rahimi, Saeed Al Hosani, Saeed Ali, Yousif Hussain

The Africa Institute
Salah M. Hassan
Elizabeth W. Giorgis, Sataan Al-Hassan, Semeneh Ayalew Asfaw

Sharjah Museums Authority
Alya AlMulla, Mariam AlHemeiri, Fatima AlZarooni, Fatima Al Raeesi, Muna Al Hammadi, Sara Eisa, Badreyya Al Shehhi, Mohamed Sulaiman, Rashed Hassan, Marketing and Communication Department

Special Thanks
Salah M. Hassan
Sataan Al-Hassan
Surafel Wondimu Abebe

Artist Assistant
Hanna Teshome

Sharjah Art Foundation Patrons
Mohammed Afkhami
Haleema Al Owais
Sultan Sooud Al Qassemi
Maysoune Ghobash
Badr Jafar
Sawsan Al Fahoum Jafar
Al Midfa Investments Group
Olivier Georges Mestelan
Reem El Roubi